Art & Soul Therapy for Kids-At-Heart

 For ages 9 to 99

Calm Coloring
Faith, Hope & Love

Big Bible Blessings
30 Designs of Inspiring Whimsy

Tracy Campbell

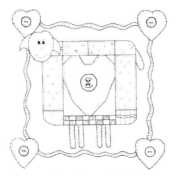

Heart for Ewe Publishing

Copyright Information

Calm Coloring: Faith, Hope & Love
(Art & Soul Therapy for Kids-At-Heart)
For Ages 9 to 99
First Edition
Copyright © 2016 Tracy Campbell
Heart for Ewe Publishing
Cover Design: Tracy Campbell
3D Mock-ups & Cover Creations: Chris Graham
Editors: Steph Beth Nickel and Joan Y. Edwards

eBook ASIN: B01G68FXDI
eBook ISBN: 978-0-9940337-0-3
Paperback ISBN: 978-0-9940337-1-0

Additional quotes sprinkled throughout were written by Tracy Campbell.
The quotes "An Act of Kindness Creates an Endless Ripple," "Worry Less, Smile More," and "Plant Seeds of Love" were written by unknown authors.

Welcome to the Delightful World of Calm Coloring

In our hectic, fast-paced world, trying to carve out "God and me" time can seem nearly impossible. The kiddies scream for attention or work demands (in and outside of the home) leave you stressed and exhausted by day's end. Maybe you're fighting a physical or an emotional battle and you've lost the desire to nurture your soul.

Whatever stage of life you're in, or whatever painful circumstances you're dealing with, please know you have a heavenly Father, the Great Conductor of Life, who cares about every precious detail.

"Yes, God even knows how many hairs you have on your head" (Luke 12:7a ERV).

And He is just waiting to unlock the window of your soul in a happy heart way—a calm coloring way. You see, we were created to express our creativity. As an artist, I express my creativity through drawing the designs. And you, the colorist, get to express your creativity through coloring the designs.

It's also no secret that coloring is a therapeutic art form known to reduce stress and alleviate anxiety. I recall a nostalgic time when I leaned over my parent's kitchen table to draw and color away my childhood worries.

No wonder coloring is one of the biggest publishing crazes to hit the market. Up until a few years ago, the adult coloring book genre didn't exist. Peter Gray, professor of psychology at Boston College, points out the benefits of coloring. He says . . .

"You're not stressing yourself out as much as you would if you were to draw from scratch, but you're still getting some of the relaxing qualities of creating." [1]

As a published artist of calendars, wrapping paper, and gift cards, and as an author of how-to-paint magazine articles, my happy heart sings again sharing the work of my hands through *Calm Coloring: Faith, Hope & Love (Art & Soul Therapy for Kids-At-Heart)*. I created this faith-filled coloring book to inspire creativity, boost sagging spirits, and bring back the God colors of your life in a fabulously fun way.

1. "Hottest trend in publishing is adult coloring books". *New York Post*. 13 December 2015.

Your life is a journey you must travel with a deep consciousness of God.
I Peter 1:18a MSG

So get ready to . . .

Pack up:

- ♥ soft core colored pencils
- ♥ gel pens
- ♥ fine-tip markers
- ♥ watercolors
- ♥ worship tunes

Take a seat:

- ♥ in a comfy chair
- ♥ in a waiting room
- ♥ in a coffee shop
- ♥ in a car
- ♥ on a train

Color in:

- ♥ 21 full-size, whimsical designs suitable for framing
- ♥ 4 encouraging gift tags to attach to thoughtful tokens of love
- ♥ 3 journal pages to jot down uplifting verses, prayers, and happy heart thoughts
- ♥ 2 motivating bookmarks to tuck into your favorite books

This calm coloring journey will unlock the window of your soul to help you find your happy heart connection with the Great Conductor of Life when you meditate, memorize, and pray over Big Bible Blessings while coloring 30 designs of inspiring whimsy in *Calm Coloring: Faith, Hope & Love.*

Our hectic, fast-paced world can wait.

All aboard . . . last call!

Happy Heart Coloring,

I'm thanking you, God, from a full heart,
I'm writing the book on your wonders.
Psalm 9:1 MSG

Big Bible Blessing Bonus

Tips for Best Coloring Results

♥ slip a piece of cardstock or a file folder between each page to prevent bleed-through when coloring with markers or painting with watercolors

♥ and remember to . . . relax

♥ ♥ ♥

Dedication

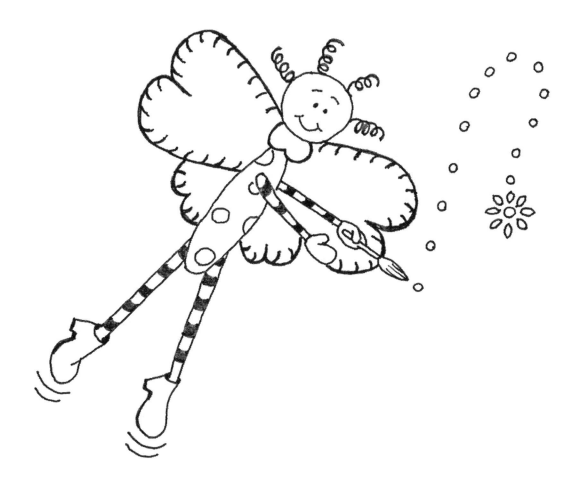

This faith-filled, inspirational coloring book is dedicated to my heavenly Father, the Great Conductor of my life, and to my supportive hubby, Danny. And it's also dedicated to everyone looking for a happy heart connection with the Great Conductor of Life.

♥ ♥ ♥

God makes people right through their faith in Jesus Christ.
He does this for all who believe in Christ. Everyone is the same.
Romans 3:22 ERV

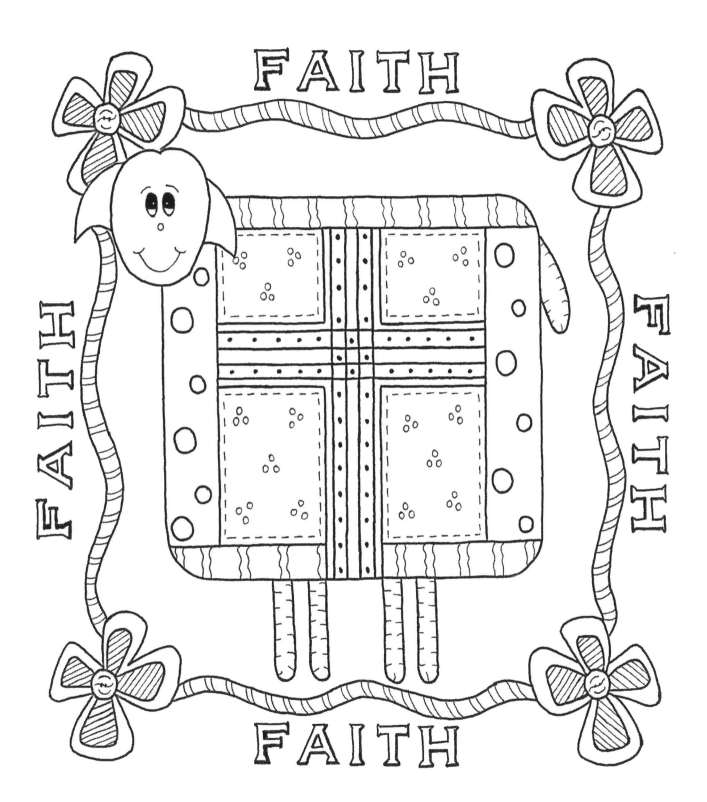

FAITH

FAITH

FAITH

FAITH

Faith is what makes real the things we hope for.
It is proof of what we cannot see.
Hebrews 11:1 ERV

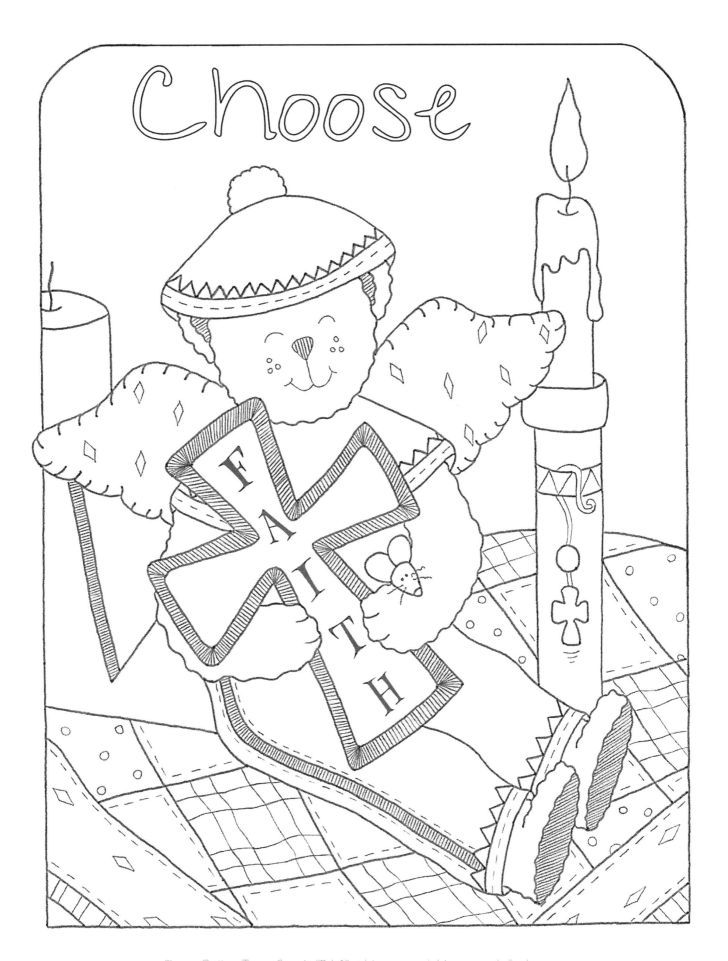

LORD my God, you have done many amazing things!
You have made great plans for us—too many to list.
I could talk on and on about them, because there are too many to count.
Psalm 40:5 ERV

God has AMAZING

Welcome

PLANs for your life.

In all the work you are given, do the best you can.
Work as though you are working for the Lord.
Colossians 3:23 ERV

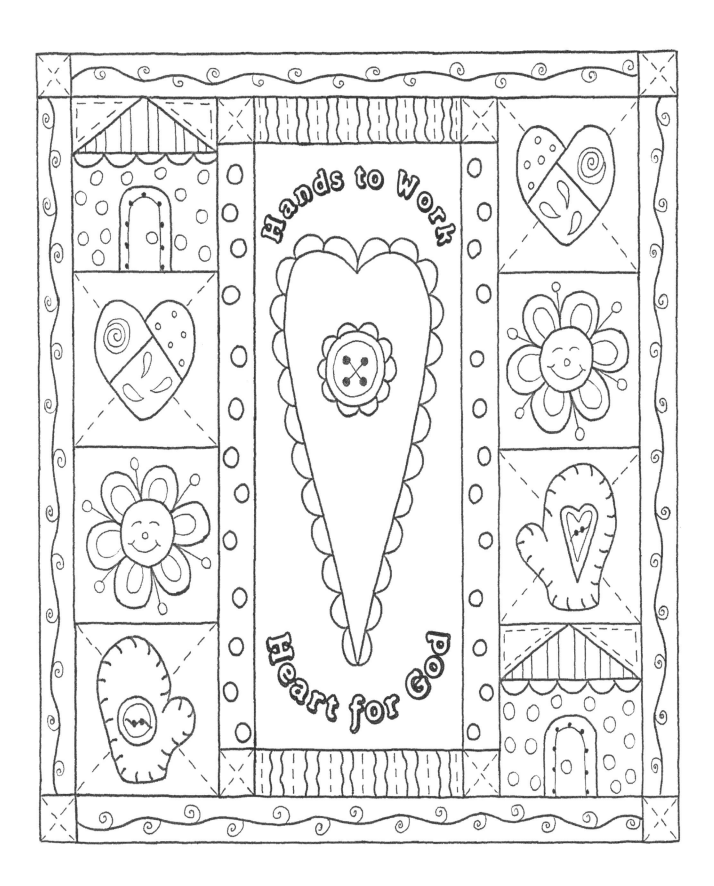

Hands to Work

Heart for God

Quiet down before God, be prayerful before Him.
Psalm 37:7a MSG

Big Bible Blessing for Rest in the Lord

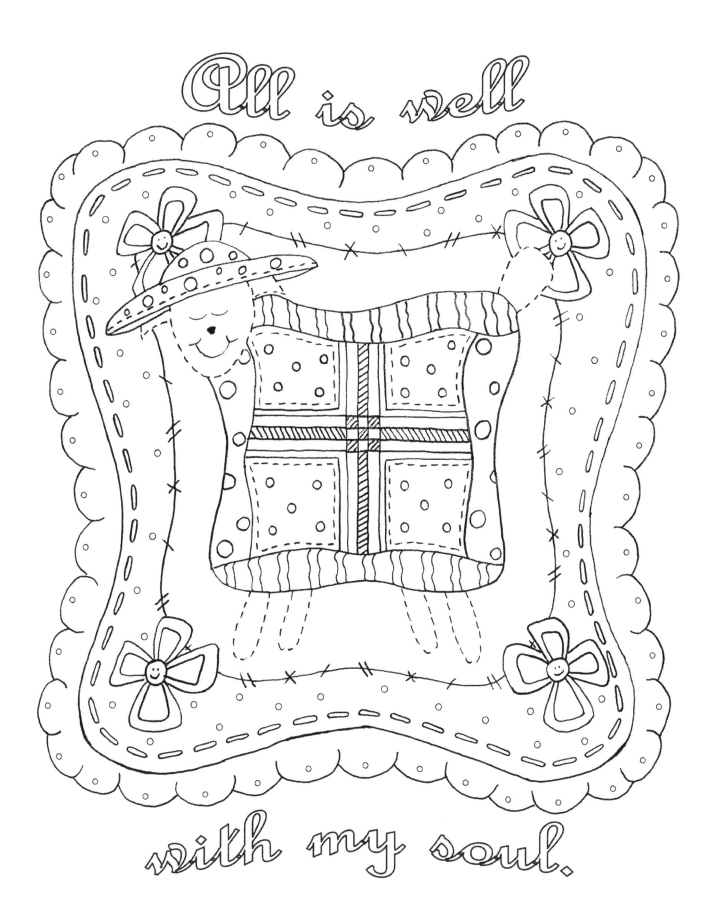

So don't worry about tomorrow.
Each day has enough trouble of its own.
Matthew 6:34a ERV

Print this page onto cardstock. Color, cut, and share the bookmarks
to encourage friends and family. Don't forget to print and color a few bookmarks for yourself
to insert into your favorite books—one like God's Word.

♥ Bookmarks of Faith ♥

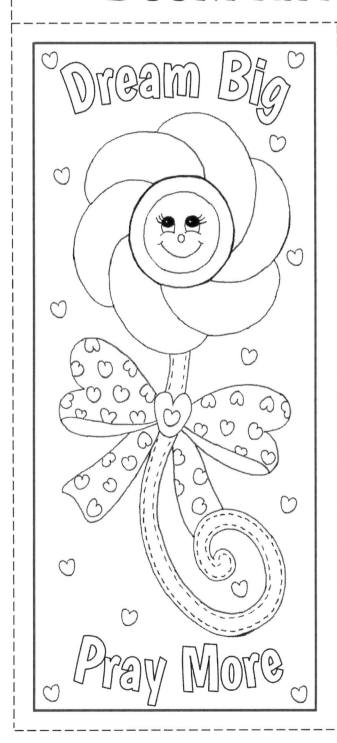

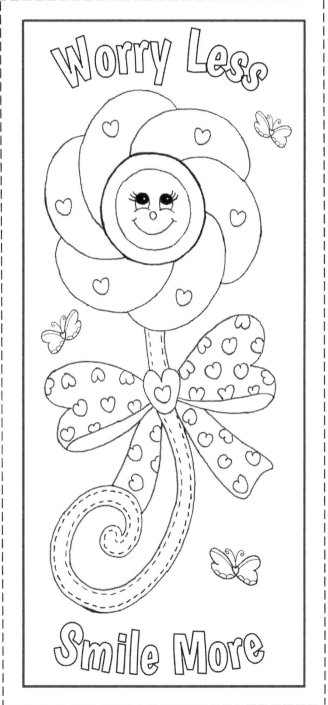

I can do all things because of Christ who strengthens me.
Philippians 4:13 MEV

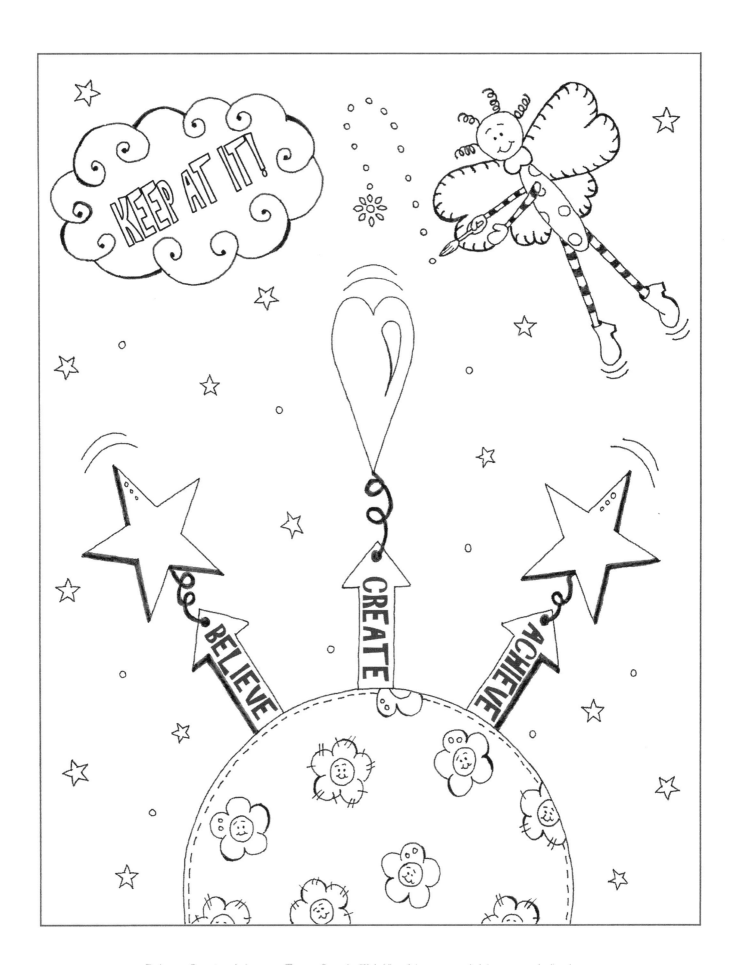

We must keep our eyes on Jesus,
who leads us and makes our faith complete.
Hebrews 12:2a CEV

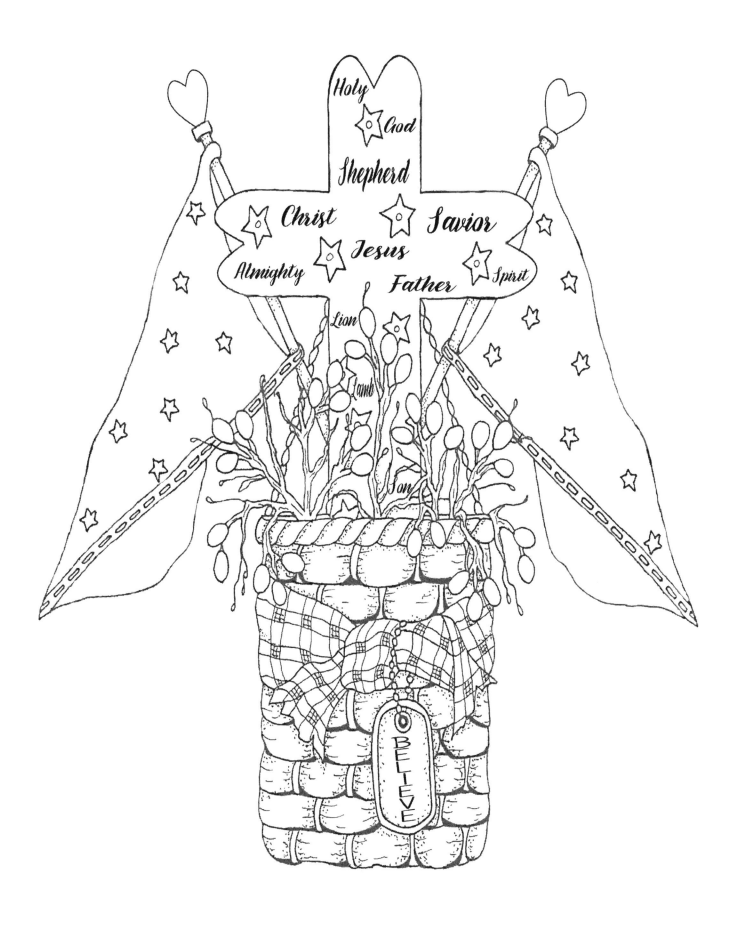

Holy
God
Shepherd
Christ
Savior
Almighty
Jesus
Father
Spirit
Lion
Lamb
Son
BELIEVE

Your word is like a lamp that guides my steps,
a light that shows the path I should take.
Psalm 119:105 ERV

FAITH

Date: *My Journal Jots*

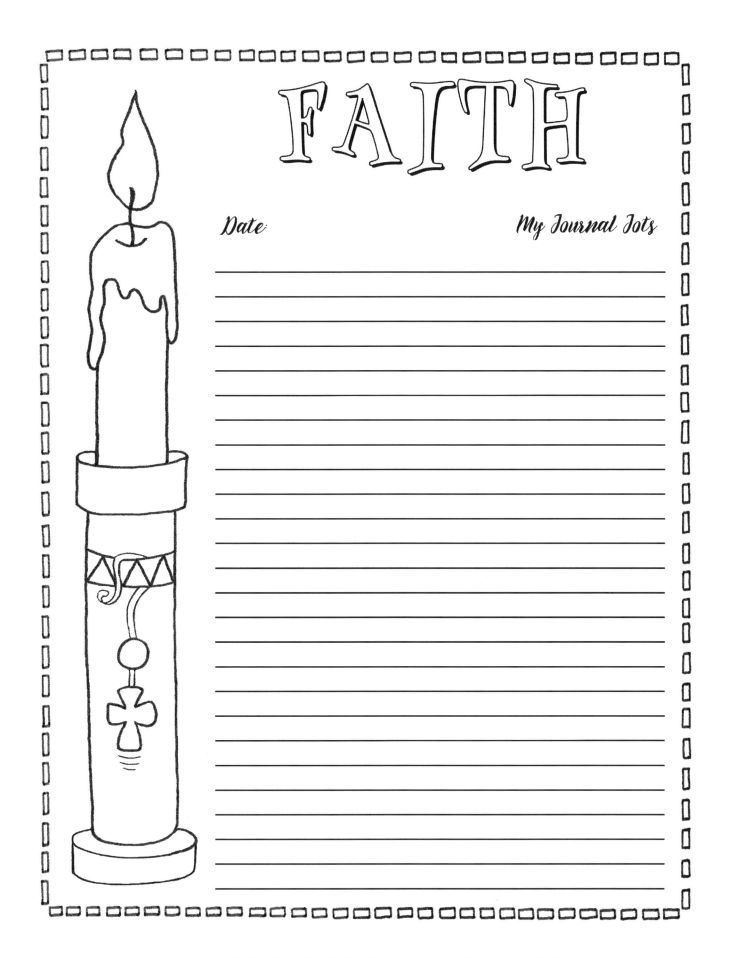

This hope is like an anchor for us.
It is strong and sure and keeps us safe.
Hebrews 6:19a ERV

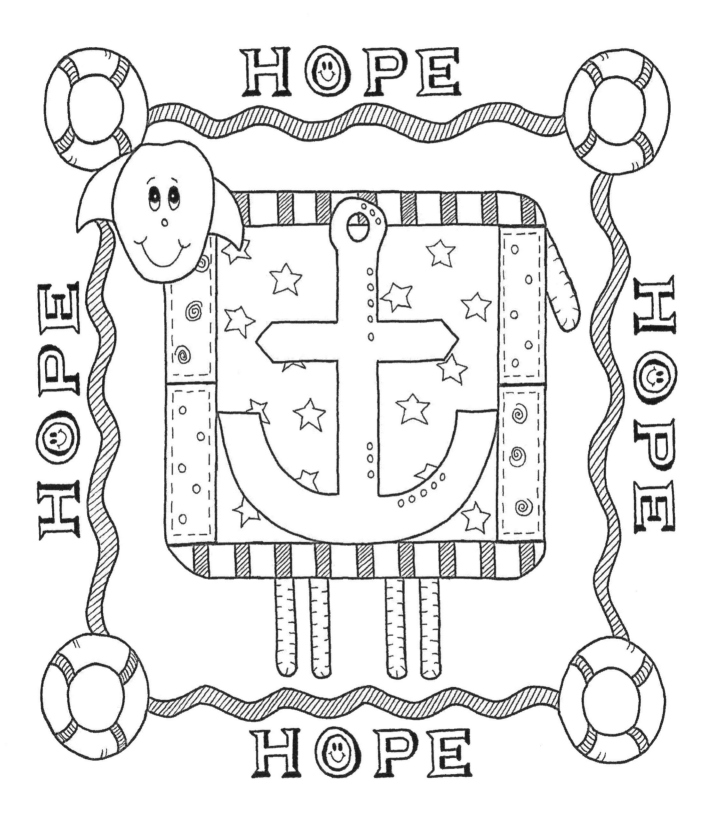

Now may the God of hope fill you with all joy and peace in believing,
that you may abound in hope by the power of the Holy Spirit.
Romans 15:13 NKJV

Big Bible Blessing for Thyme to Hope

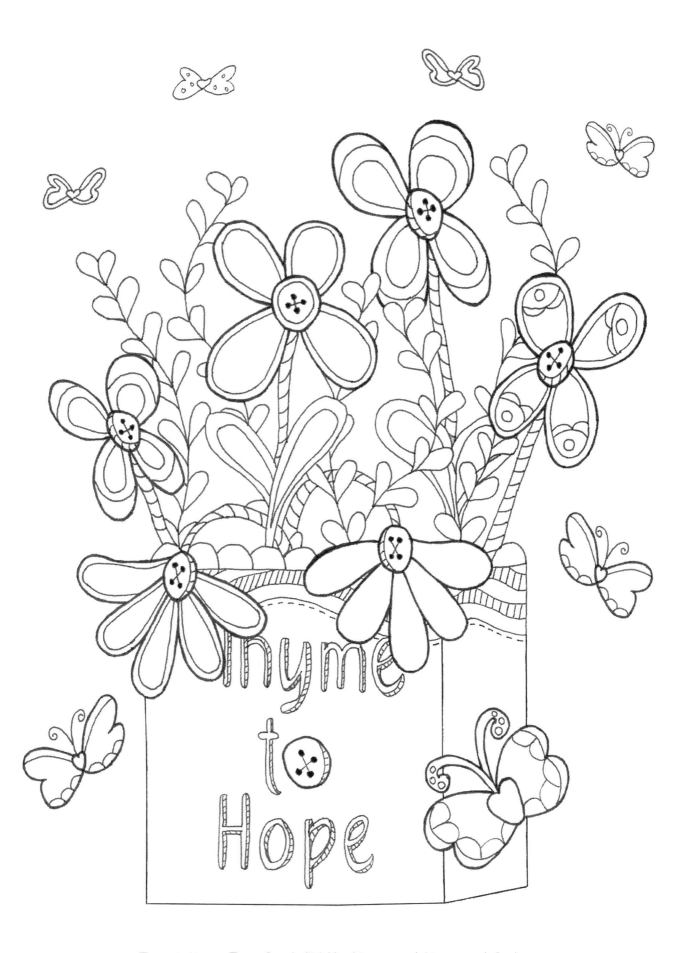

He will wipe away every tear from their eyes. There will be no more death, sadness, crying, or pain. All the old ways are gone.
Revelation 21:4 ERV

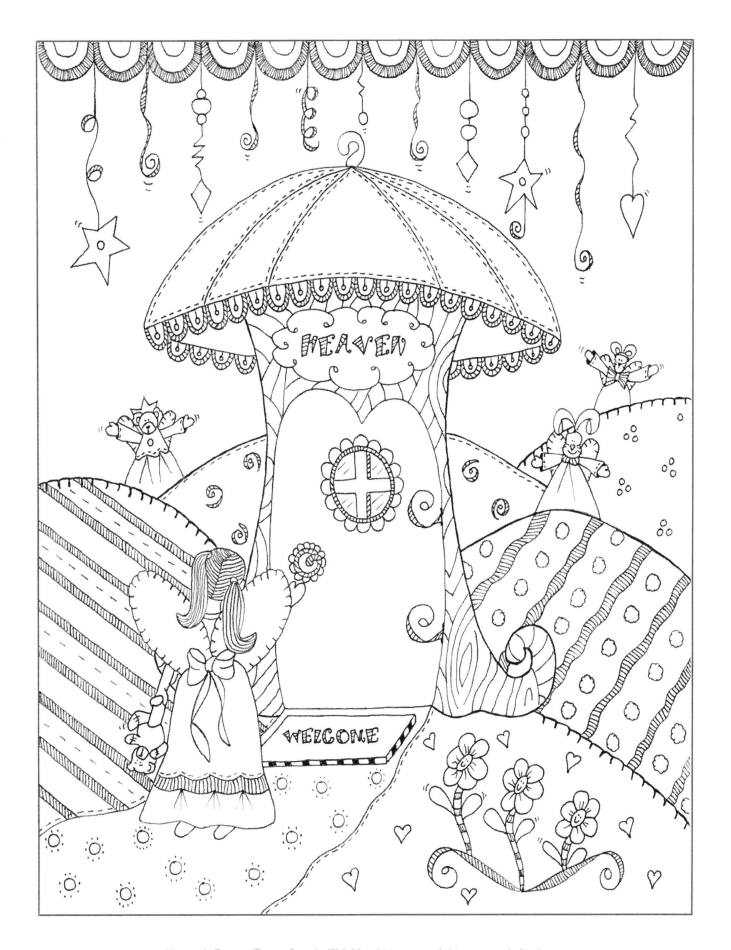

Hope that is delayed makes you sad,
but a wish that comes true fills you with joy.
Proverbs 13:12 ERV

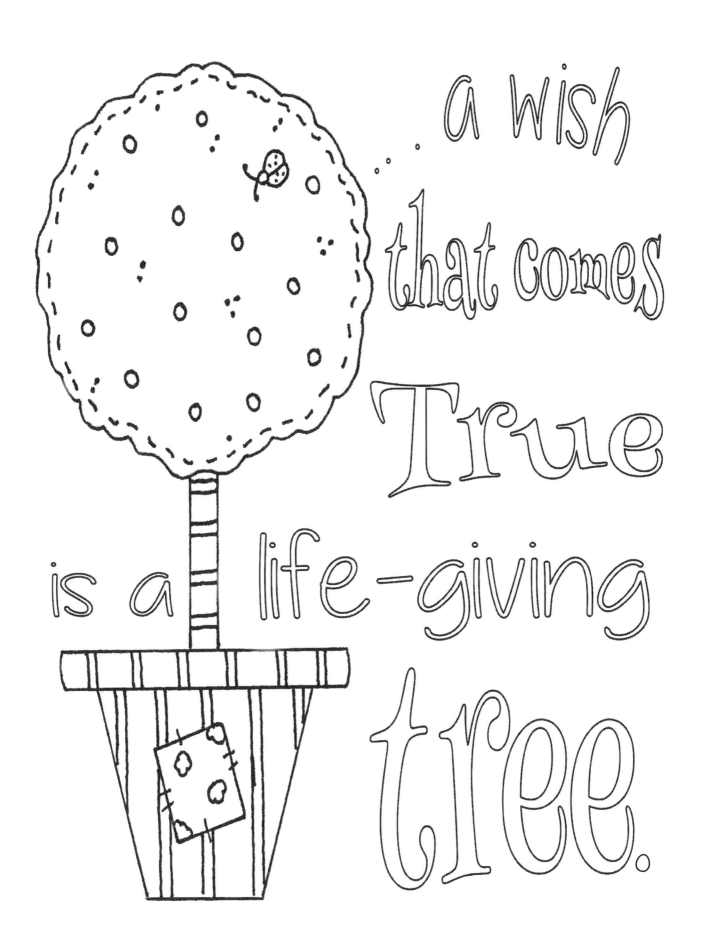

a wish
that comes
True
is a life-giving
tree.

God made my life complete when I placed all the pieces before him.
2 Samuel 22:21 MSG

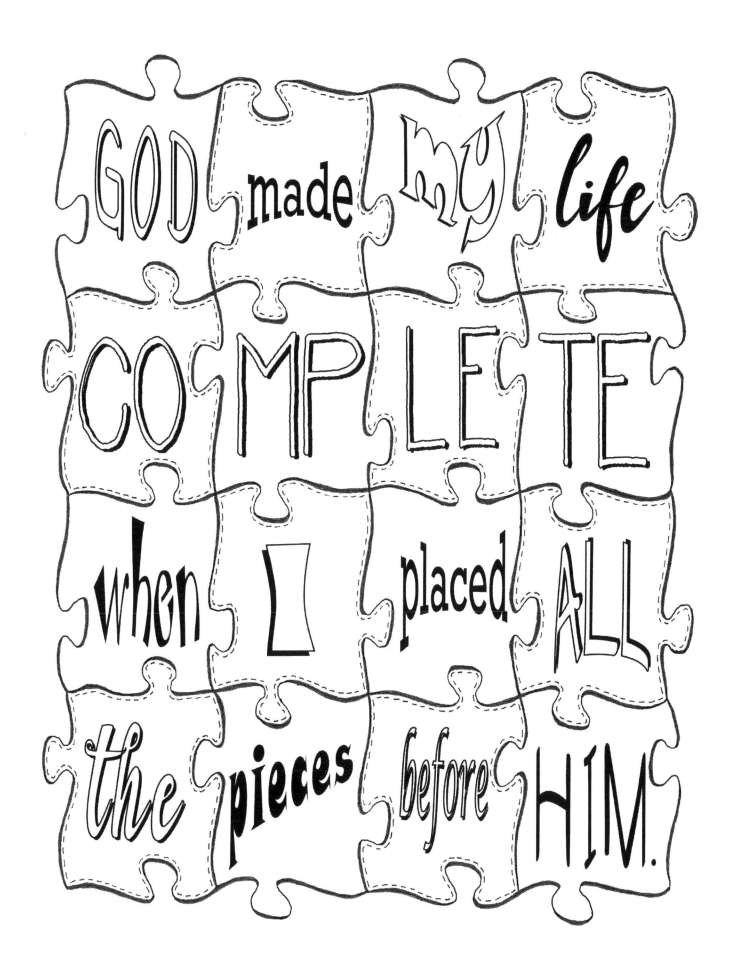

Depend on the Lord for strength.
Always go to him for help.
Psalm 105:4 ERV

Place your hope in

The Great Creator.

We were made right with God by his grace. God saved us so that we could be his children and look forward to receiving life that never ends.
Titus 3:7 ERV

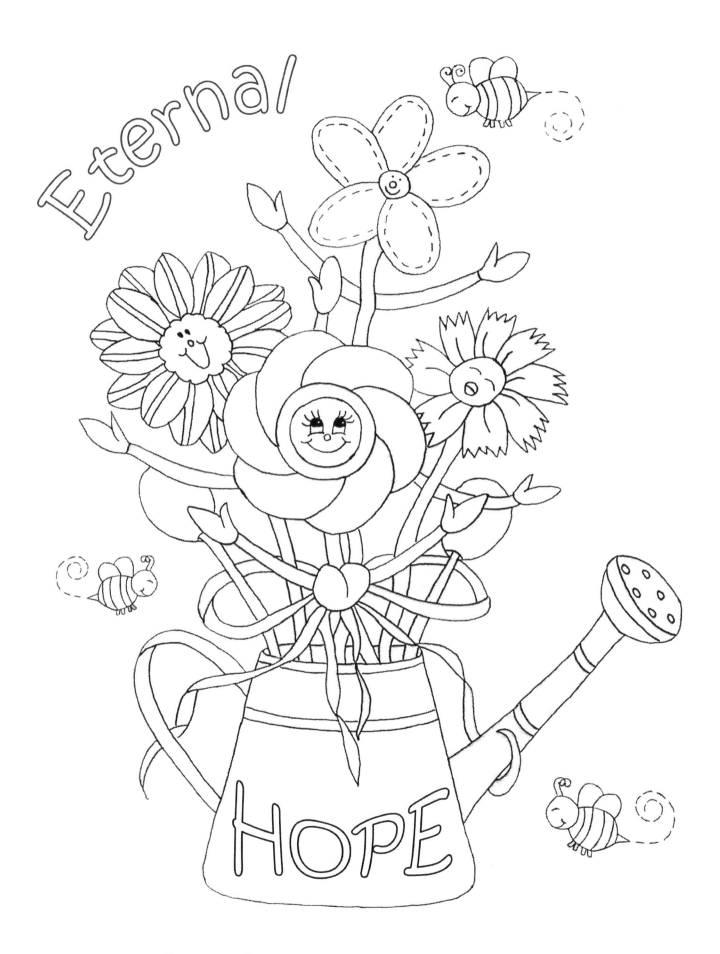

When someone becomes a Christian, he becomes a brand new person inside.
He is not the same anymore. A new life has begun!
2 Corinthians 5:17 TLB

HOPE

Date: My Journal Jots

Where butterflies soar so does hope.

I am the good shepherd,
and the good shepherd gives his life for the sheep.
John 10:11 ERV

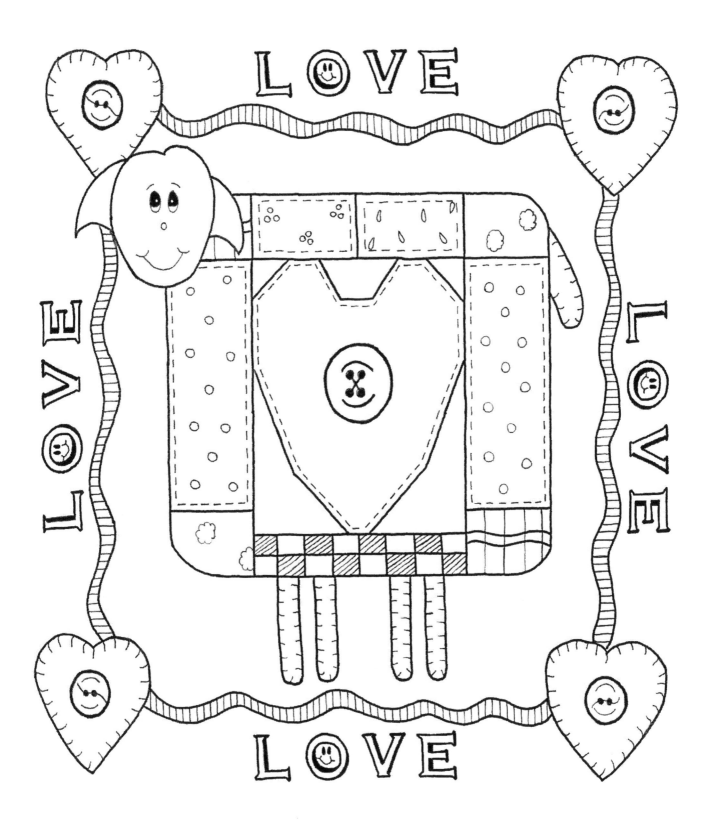

A sweet friendship refreshes the soul.
Proverbs 27:9b MSG

Big Bible Blessing for A Gift of Love

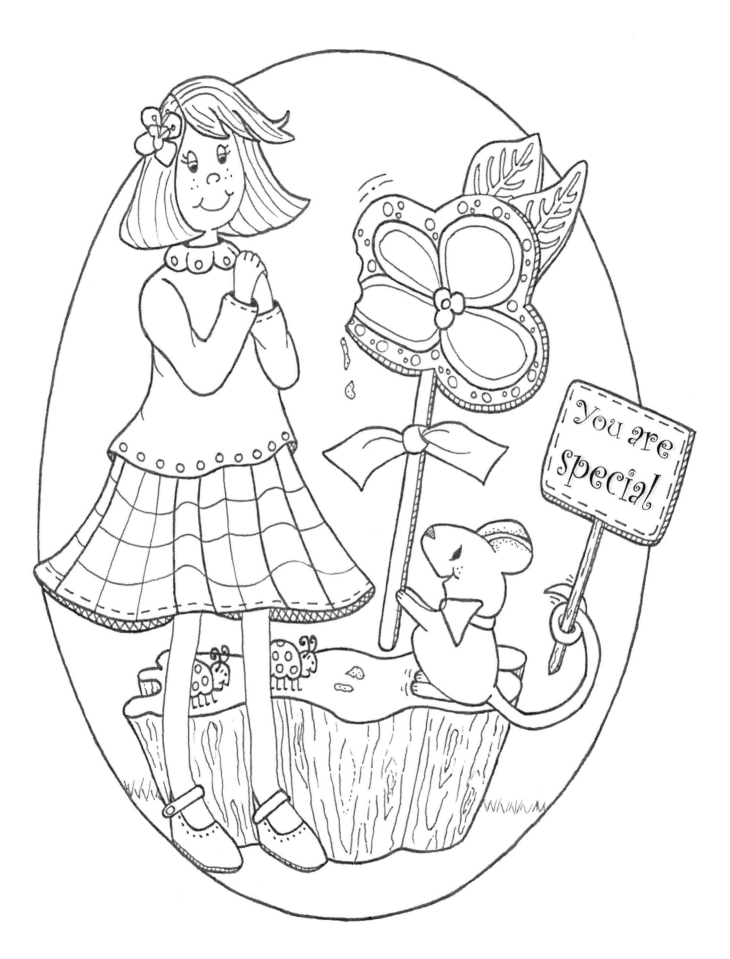

you are special

May the Lord smile down on you and show you his kindness.
Numbers 6:25 ERV

Big Bible Blessing for An Endless Ripple

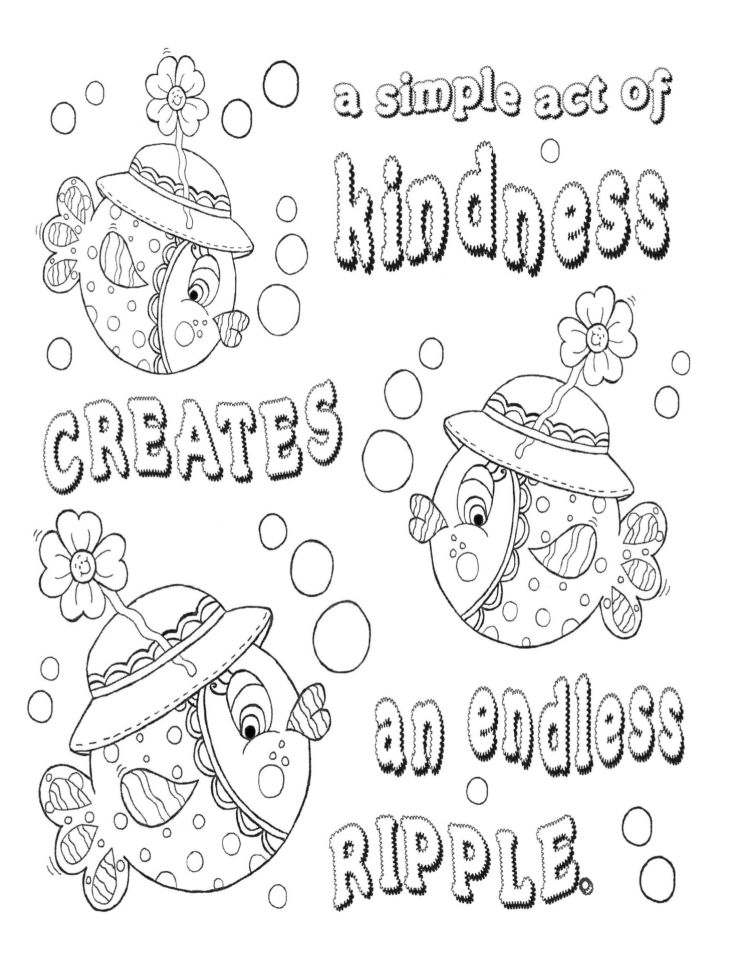

a simple act of **kindness** CREATES an endless RIPPLE.

I pray that Christ will live in your hearts because of your faith.
I pray that your life will be strong in love and be built in love.
Ephesians 3:17 ERV

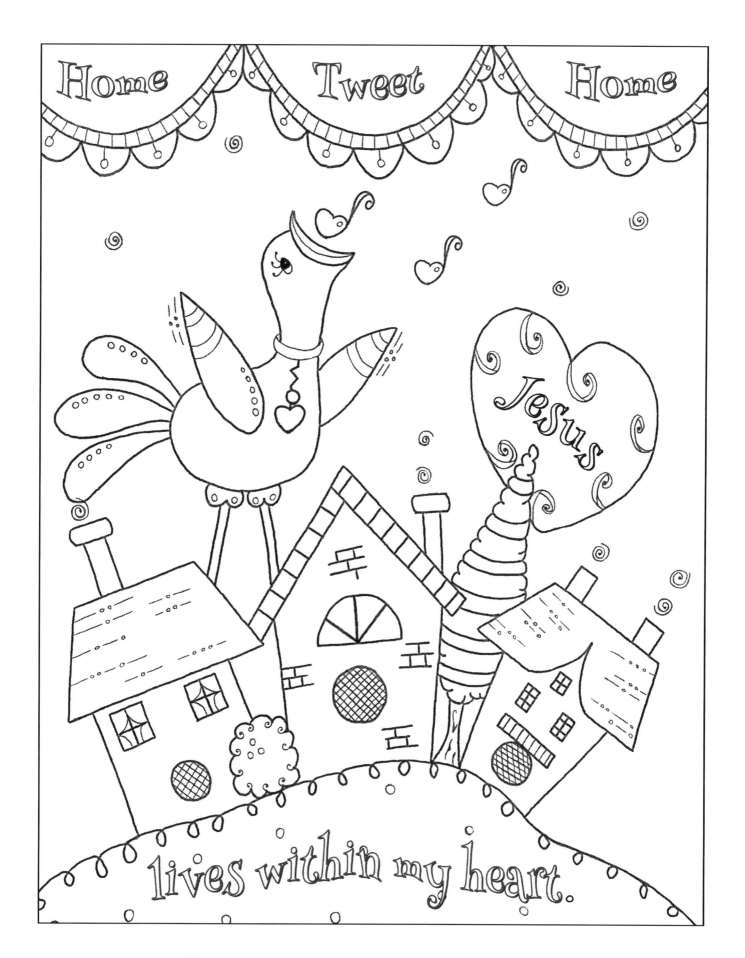

Every morning, Lord, I lay my gifts before you and look to you for help.
And every morning you hear my prayers.
Psalm 5:3 ERV

How to Make Gift Tags

♥ print this page onto cardstock,
♥ color each gift tag any way you wish,
♥ cut out each tag as close as possible to the solid black border,
♥ use a small paper punch to make the hole,
♥ write a note on the back of the gift tag,
♥ thread a ribbon through the hole,
♥ attach the tag to your gift. ☺

To:

Praying for God to protect you!

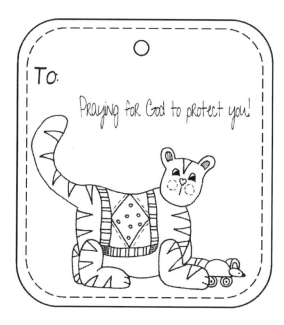

To:

Blowing kisses your way.

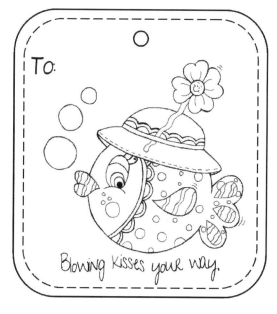

To:

We love you!

To:

Sending you a warm hug.

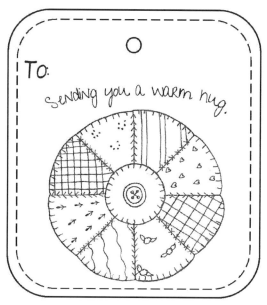

Forget about the wrong things people do to you.
Leviticus 19:18a ERV

Big Bible Blessing for Love Your Neighbor

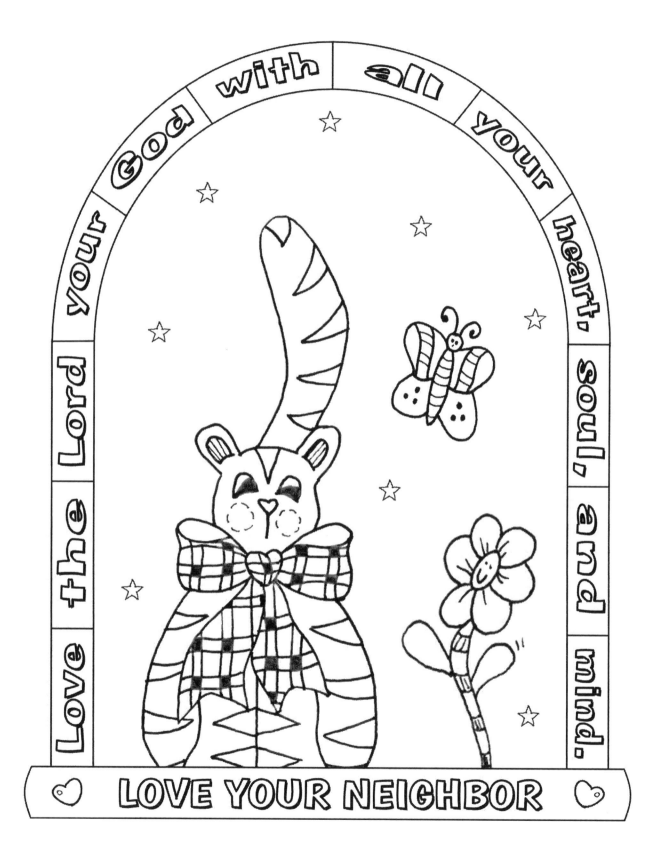

Love the Lord your God with all your heart, soul, and mind.

LOVE YOUR NEIGHBOR

For God is great, and worth a thousand Hallelujahs.
Psalm 96:4a MSG

Big Bible Blessing for Hallelujah

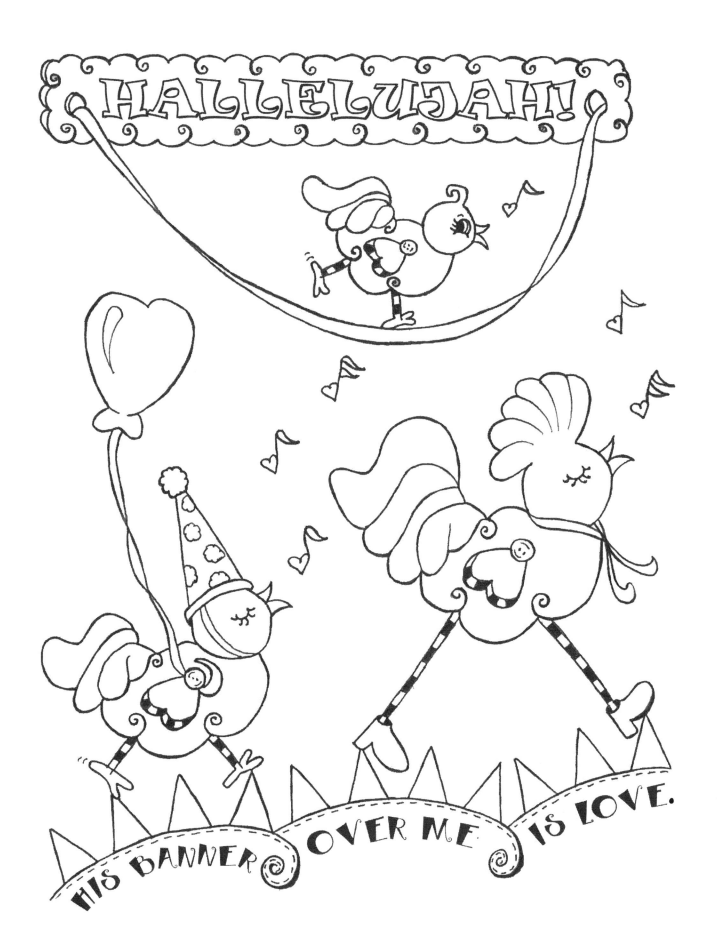

I am with you, and I will help you.
People will till your soul and plant seeds in you.
Ezekiel 36:9 ERV

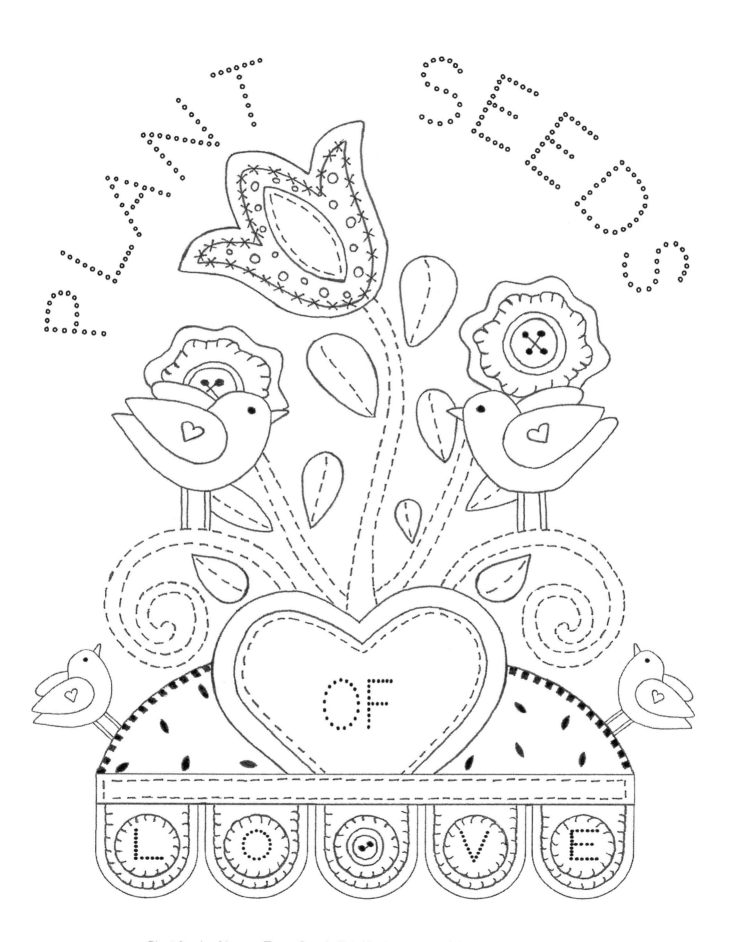

Friends love through all kinds of weather,
and families stick together in all kinds of trouble.
Proverbs 17:17 MSG

LOVE

Date: *My Journal Jots*

Always . . .

love

each

other.

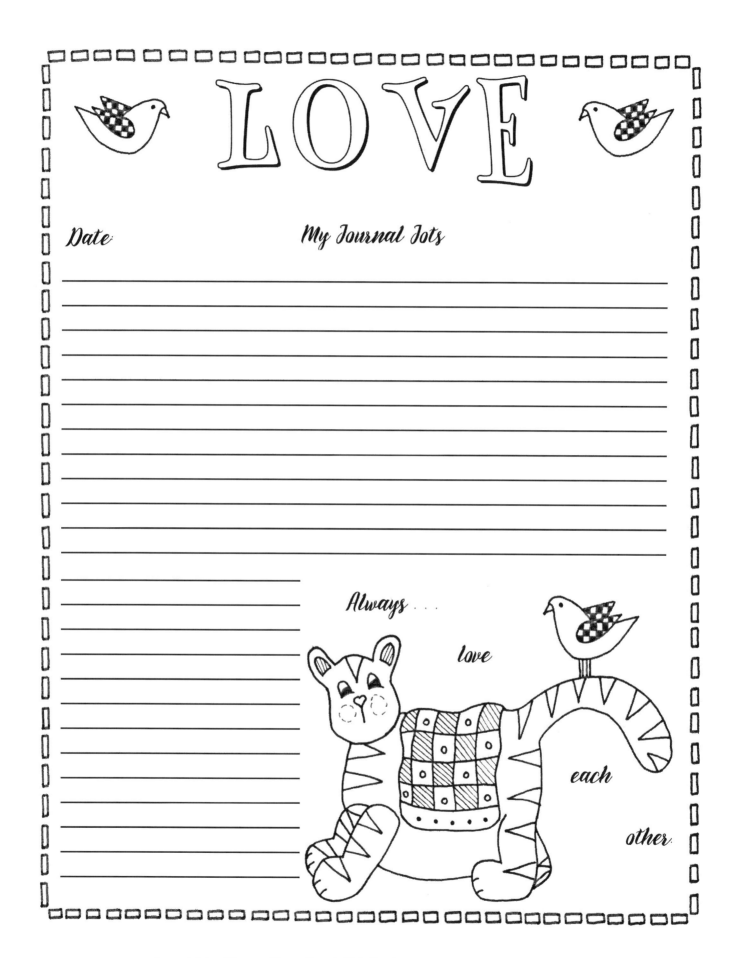

There are three things that remain—
faith, hope, and love—and the greatest of these is love.
I Corinthians 13:13 TLB

Big Bible Blessing Bonus

Meet Tracy

"In all the work you are given, do the best you can" (Colossians 3:23a ERV).

Tracy Campbell is a published artist, author, and a retired interior design professional who aims to perfect the creative abilities God has blessed her with.

When Tracy's not writing, she loves to sharpen pencils, flip open paint lids, and yank off marker caps to create whimsical works of art just for ewe.

Customers say her art is sweet and so warm the designs might leap off the page and land right in your heart.

She lives with her hubby and fur baby in Wasaga Beach (the Canadian tourist town known for having the longest freshwater beach in the world).

Tracy is also a rare breed dog owner, chocoholic, motorcycle mamma, antique lover, and a collector of roosters and sheep (thankfully, not live ones).

♥♥♥

Happy Heart Suggestions

Should you wish to share your colored pages from this book on any social media site, Tracy would appreciate a link back to her Wacky World of Writing and Whimsical Works of Art blog over at tracycampbell.net/blog so others can have an opportunity to enjoy her writing and whimsical art.

Tracy would love to feature those same pages on her blog. Please email tracy@tracycampbell.net for easy peasy details.

Tracy features printable notecards, whimsical greeting cards, and other goodies over at tracycampbell.selz.com. Her whimsical art also appears on tote bags, pillows, shower curtains and other home décor products that are available for sale over at tracy-campbell.pixels.com.

Join Tracy on Facebook and Pinterest. Don't forget to sign up and follow Tracy over at tracycampbell.net/blog to be among the first to be notified of future books and other treats. Please be assured your email address will never be shared or sold. You may unsubscribe at any time with the click of a button.

Urgent Plea for Help

Hi, my name is Indy. I'm Tracy Campbell's fur baby. Thank you so much for purchasing Mum's faith-filled, inspirational coloring book. We would love to hear what you have to say. So please consider leaving Mum a helpful review on Amazon.com and Amazon.ca and on Goodreads. Reviews mean the world to any author. It's like receiving a delicious bone. *Woof!* And thank you!

Coming Soon

Tracy Campbell's whimsical art, tucked between the pages of *Baby & Me*, debuted on a Baby's First Year calendar and now assists in the delivery of a dozen rocking rhymes about fun-loving Baby and Mommy firsts.

Meet a pickle-crunching Mom who is desperate to choose a name that's not too wild but not too tame. Drop in on a family tree, blooming with sky-diving grannies and fly-fishing aunties. And spin through the Milky Way with Giant Neptune as he hollers, "Glad you're here to stay."

Children, small and tall, will read in no time, mimicking all of the hilarious and heartwarming read-aloud stories.

Baby & Me makes the perfect gift for new and expecting moms to unwrap at their baby shower.

The mini companion book, *Calm Coloring: A Dozen Rocking Designs (Art & Soul Therapy for Busy Moms)*, will soon be delivered too!

Big Happy Heart Thanks Goes To . . .

Steph Beth Nickel, my editor and a talented author, for taking my frantic calls and emails.

Joan Y. Edwards, another talented author and editor, for offering a free critique.

Virginia Wright, a gifted author, and precious friend, for all of her invaluable help.

Deb Wilson, my supportive, accountability buddy. I thank God for putting us together.

Chris Graham, The Story Reading Ape with heart, for creating amazing 3D mock-ups and for combining the covers.

Self-Publishing School, for providing step-by-step instructions on how to get this coloring book published. I highly recommend this course to anyone who wants to write and publish a book in 90 days.

And to the entire Launch Team ... Words can't express how grateful I am for the support I've received by way of social media shares, reviews, and encouragement. Thank you, too, to those who purchased this book. I hope you enjoy it. May the book be a blessing for you. ☺

A Thank You Bonus

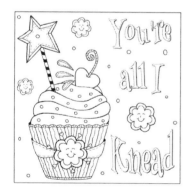

To claim your thank you bonus, please type "tracycampbell.selz.com/item/printable-coloring-page-baked-with-love" in your search engine. Click "Buy It Now", enter the discount code KNEAD (case sensitive), click "Apply". Enter your name and email address (your email address will never be shared or sold), and then click "Continue".

Voila! Your coloring page will be ready for you to download.

A Heart of Gratitude

My heart overflows with gratitude toward my heavenly Father, who encouraged me through each of the Big Bible Blessings. And as I traveled down the bumpy road to publication, I also witnessed the touch of His hand through the helpful folks He sent my way. Thank you, God, for constantly reminding me to . . .

"Relax, everything's going to be all right,
rest, everything's coming together" (Jude 1:2a MSG).

Made in the USA
Charleston, SC
29 June 2016